Journey the Heart

POETRY AND PICTURES

LISA MANALE
JOSEPH MANALE

This book is dedicated to the memory of my wonderful,
loving father, Joseph Manale
who passed away during the production of this book.
Since my childhood, he taught me right from wrong, about
honesty, respect and morals and most
importantly, the value and significance of family.
He had given to me his creative
side of music and writing and I am grateful that we were
able to share this same passion together
on this incredible journey.
I know his legacy will live on with all he ever shared and
expressed in his life and that he will
forever keep close watch over me from the balconies of glory.
His new journey has just begun....

~ Lisa

Table of Contents

Preface

In this second poetic memoir written by myself and my father, be ready for a potpourri of love and loss on many levels.

You will read about our childhood and teenage memories, good times and young love, the beauty of promising relationships and the disappointments of the unexpected endings.

Hopeful connections, self preservation, fear to love and surviving the storms of life's decisions on the realities of everyday emotions.

We wanted to touch on subjects that were not just about happiness and heartbreak with all we've encountered but a little extra of emotional and amusing subject matter.

Although much of our writing is about our past experiences in relationships, we wanted to also express in words, stories of loved ones we've lost to illnesses and tragedies.

From surviving cancer, taking care of a loved one and experiencing the loss of our friends and family with illnesses, addictions and suicide, we wanted to reach you, the reader, in many, if not all of our stories in our words of how it has affected us, our lives and our memories.

My father, Author, Joe Manale also wanted to include a handful of funfilled poetry of true memories to make you laugh, a little fantasy to make you dream and some of the unknown to make you wonder.

My Dad and I share similar styles in our poetry. Our past inspires us to express ourselves with stories from the heart, challenges of the mind and bringing passion to the soul.

I believe there is a vulnerability not just in poetry but with any form of expression that shows the world what you refuse to suppress of what's deep inside of you and that you are humbled by your experiences and touched if you reach even one person that can relate to your words.

After writing our first book, Seasons of the Soul, we were further inspired to share so much more of our recollections of what we had stored away throughout the years.

As in our first book, the integrity of every poem is raw and forthcoming and meant to reach and relate to every reader somehow.

We hope that our words make you laugh, cry, understand, help, give you aspirations, strengthen your mind and that you feel a comfort and normalcy that many of us share; an abundance of the same emotions and struggles.

There are numerous levels of love and how we deal with the good and the bad and the highs and the lows. Find what lies deep inside of you that is dormant and wake up your inner soul and live, share, express and show love without judgment or facades.

In this book, we also wanted to do something different with the images shown for your viewing experience.

In Seasons of the Soul, we wanted to hallmark a variety of my father's paintings to give the reader a visual stimulation while reading the book.

For our second memoir, we thought including some photographs would be a nice change. We decided to incorporate some of my own photos and also have other featured photographers contribute some of their incredible work in this journey.

Enjoy yourself in this short life, make a difference, pursue your passions and live your dreams.

Sit back, rest the mind and relax and enjoy this read that will undoubtedly touch your heart.

Acknowledgement

A Special Thank You to the incredibly talented and remarkable photographers that agreed to be a part of this book and share some of their phenomenal work inside of Journeys of the Heart.

Featured Photographers:

Al Picallo

Myra Baldwin Thiessen

David Minter

Jeff Hartzog

Dave Allen

"Emotion is written upon the scars of experience."

~ Steve Lynch

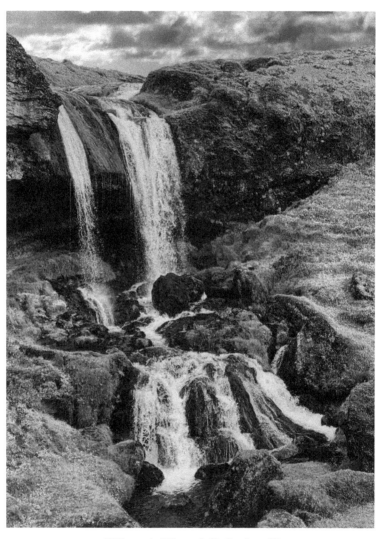

"Sheep's Waterfall, Iceland"
Photo by Jeff Hartzog

Let Me Love you

Let me be your lover
that you've never had before.
Let me show you a glimpse of me
and leave you wanting more.

Let me share my thoughts and dreams
and help me see them through.
Let me take you for this ride,
a journey that's tried and true.

Let me express my passion
in a way you can't resist.
Let me fill your heart,
where without me, I'd be missed.

Let me give you my loyalty
and what it means to have a true friend.
Let me show you love like no other
where you never want it to end.

- LM

Someday I Hope

Someday I hope you'll remember
all our moments you wanted so much.
Someday I hope you will think of the way
I looked at you and the feel of my touch.

Someday I hope you will see
that God's reasons for us are whole.
Someday I hope you'll embrace
that you somehow brought light and woke up my soul.

Someday I hope you will smile
when you reminisce the passion when we kissed.
Someday I hope you will realize
the many more memories with me you have missed.

Someday I hope you'll feel grateful
of your life with me being a part.
Someday I hope you'll see clearly
that all along you've had all of my heart.

Someday I hope you'll believe
that you are deserving of the love that I gave.
Someday I hope that you'll think
that what we have is something to save.

Someday I hope you will understand
that our connection is one of a kind.
Someday I hope you will cherish
wonderful moments when I come to mind.

Someday I hope you'll have tears of joy
when you look back with the laughter and the fun.
Someday I hope you will miss
the intimate times and all that we've done.

Someday I hope you will trust in good reasons
of why our paths have crossed.
Someday I hope you'll wake up
before realizing all that you've lost.

Someday I hope your heart will be open
and see who I am and all that is true.
Someday I hope you won't throw away the good
from the fear of knowing that I love you.

Someday I Hope...

- LM

No Hard Feelings

Once a romance is finally over
and you know it's time to go.
Just make your exit short and sweet,
no need to put on a show.

When love has gone, I mean really gone
and there is nothing you can do,
don't beg and make any promises,
you may come off looking like a fool.

The faster you end a failed romance
and not think of the pain you feel,
you will make the time to forget
and finally begin to heal.

There is a chance you may fall in love again
in the coming years ahead.
I have given my knowledge of relationships to you
and finally run out of words...good luck, enough said.

- JM

One Sided Love Affair

She was a very special person to me
and that's the reason I still care.
I think about our time together
and miss the love that we shared.

But when the one you love has gone and left
and your heart strongly beats still.
You will believe there's a void inside,
that no one else can fill.

For this is what love does to you,
sounds crazy but it's true.
You really hope you can try and fix it,
but sadly that's all you can do.

It's impossible to explain this to someone
that has never been in love before.
And the one you thought really loved you, says Goodbye
then walks out the door.

Days that were once full of sunshine,
have now all become dark.
To you it was true love,
but to her it was just a lark.

Sometimes it's hard to forget,
no matter how much you try.
But with a little luck, someday you'll find love again
before you grow old and die.

- JM

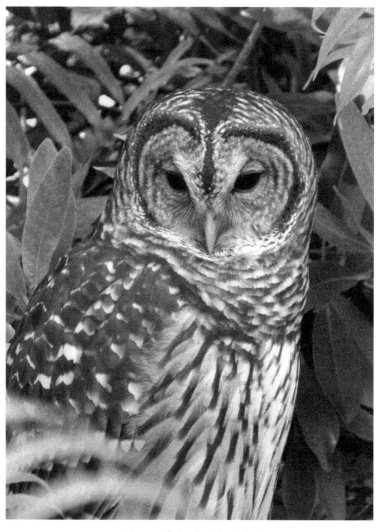

"Barred Owl, Florida"
Photo by Lisa Manale

Hindsight

Maybe we should have done things differently
in the way we met.
Maybe our timing for each other
was just not ready yet.

I wonder if we had just stayed friends
and not got together right away,
that maybe you'd be in my life right now,
somehow, some way, today.

I shouldn't have been so anxious
to give you all of me.
I guess just wanting to make you happy
was all that I could see.

We both wanted so much to feel loved,
that part will always be true.
Maybe if you had been ready with all that I gave,
that you'd still want me too.

- LM

Mom

It's been 10 years ago since you left us Mom,
and this life is so different now.
Without your guidance,
Without your Love,
I have made it through somehow.

I remember the day you passed away,
and how I prayed for the sadness to end.
Alone in my sorrow,
Not sure what to do,
I had lost my only best friend.

I still talk to you as if you were here with me,
and imagine the moments of all that was good.
I think back on the memories,
the talks and the tears,
And would do it all again if I could.

I feel relief that you are at rest,
and no longer suffering anymore.
The difficult years,
the endless pain,
I try to remember your life and how it was before.

I've needed you so many times througout challenges,
in these days that have fallen apart.
Battling cancer
and losing so much,
I still carry the love of you in my heart.

Your voice and your laughter, your sweet and giving ways,
are forever stuck in my mind.
Your warmth and your beauty,
the kindness of your soul,
Mom, you were one of a kind.

Someday when I'm gone and leave this world behind,
as I know my time will come too.
No more fears, no more sadness,
Just smiles and pure hearts,
And a celebration when I finally see you.

- LM

Bewildered

Is there a cure for loneliness?
I wish I really knew.
I feel oh so lonely,
after losing you.

I thought we had so much in common,
you could say we were two of a kind.
I wish you had told me what went wrong,
was I too overbearing or just way out of line?

Dreams of Love come and go,
it changes like the weather.
One day you are all alone,
next day you're happily together.

One day it is storming,
and the next day, all is clear.
I guess it's those calm clear days
that you long for and hold so dear.

- JM

I Hope

I hope you like long hugs,
soft kisses and affection.
We already have great talks and laughs
in this feel good connection.

I hope you don't mind if we sit and relax
and let me read you a book.
I hope you know what it means
when I smile and give you that look.

I hope no matter where we are,
we will hold each other's hand.
I hope we can always talk to each other
so we always know where we stand.

I hope what we have is real
and that our bond will strenghten over time.
I hope my dreams will finally come true
and that you will forever be mine.

I hope...

- LM

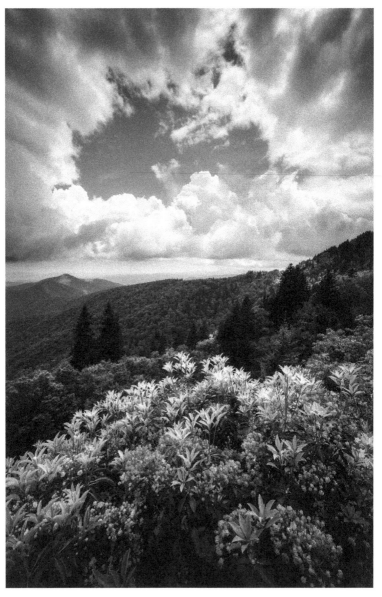

"Blue Ridge Mountains, North Carolina"
Photo by Dave Allen

The Joy of My Life

Her name was Joyce but I called her Joy,
she was the perfect wife.
And she brought joy to everyone
that came into her life.

She was eleven when we first met,
I had just turned fifteen.
Nine years later we were married,
a happy ending to a dream.

We have two beautiful children,
new life is such a miracle, an event.
Children give their parents so much joy,
they really are Heaven sent.

Joyce suffered for many years
from a disease that was terribly bad.
The doctors could do absolutely nothing
for the illness that she had.

Although she took medication
to try and lessen the pain,
It just worked for a little while
and the pain would return again.

Joyce put up a galiant fight
until the very end.
Sadly my children lost their mother,
And I lost my best friend.

- JM

The Trade Off

I have said this once before
and all you one time teenagers know what I said is true.
Before becoming an adult,
there are many stupid things you may sometimes do.

After high school, I bought a motorcycle
and proudly went around to show it to all the guys.
I said with just a twist of the throttle,
this machine can really fly.

I would go to Daytona beach
for so many motorcycle races,
and it was always nice to see
so many familiar faces.

One day while I was out riding
a dog ran into the street.
I was very lucky and only missed it
by just a couple of feet.

At times like this, what they say is true,
your past life you just might see.
I was fortunate and felt that some divine power
was watching over me.

One day my front tire went flat
while doing sixty miles per hour.
And if I told you I had complete control of the machine,
there's no doubt, I would be a liar.

Then one night my wife told me, you're going to have to
sell the motorcycle.
There are more important things coming, you see.
I'm pregnant now and it's time for you
to settle down and raise a family.

The thought of never riding again,
was very depressing for me,
but the good thing was that some of the money from the
sale would pay the baby's doctor fee.

- JM

Drawn to Red Flames

She had skin like porcelain,
her hair was flaming red.
I should have turned and walked away
but I walked towards her instead.

I felt she had cast a spell on me
and I know that does sound silly.
But I was completely overwhelmed
by her extreme and natural beauty.

I've always had trouble with redheads in the past,
so second thoughts keep coming to mind.
I'm sure the right one will happen for me,
it's just a matter of time.

- JM

Teach Me

I'm learning more and more
that you appreciate all I've shown.
I'm learning that you need me
but sometimes you want to be alone.

I'm learning your imperfections
and all that makes you who you are.
I'm learning what's in your heart, not what you've done
that makes you a star.

I'm learning you have bad days
and may not know what to say.
I'm learning how to tell you
that everything will be okay.

I'm learning we're already special friends
and on me, you can rely.
I'll keep learning how to express to you,
we have something real, we can't deny.

- LM

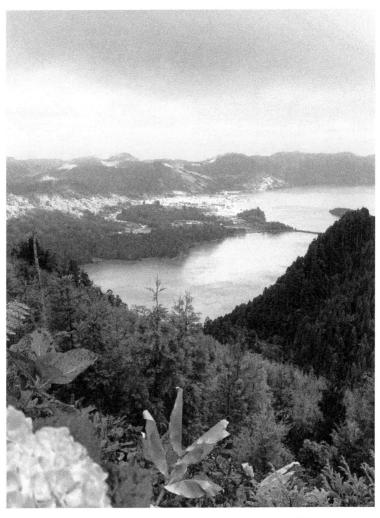

"São Miguel Island-Azores, Portugal"
Photo by Jeff Hartzog

My Love, My World

How big is our love with you and me?
From coast to coast and sea to sea.
From mountain tops across the land,
to remote islands in the sand.

The valleys and the hills when it's hot or cold,
any destination where love stories are told.
Through forests and jungles and across the ocean floor,
deserts and waterfalls and oh so much more.

With multi colored landscapes and auroras in the sky,
to catching shooting stars in the blink of an eye.
Across the Earth, there is so much to see.
Our love is so big, it's the world with you and me.

- LM

Let Down Once More

I woke up to a tearful message from you,
the words I did not want to see.
If affected me in a way I didn't expect,
to hear you say you weren't ready for me.

Although I understand your reasons
of what you explained and why,
a sadness came over me as I didn't know what to say,
all I could do was cry.

I guess we were so excited in a refreshing way,
when we first began to talk on the phone.
The laughter, the talks, the feeling of a connection we
made,
and now we're back to feeling alone.

I know you feel lost and struggling with so much,
and the battle you have deep down inside.
If there's one thing I want you to be sure about,
know in me you can trust to confide.

I was so much looking forward to touching your skin,
and enjoying every moment we could spend.
I'm so bummed that I'm not going to see you now,
but I respect that your mind is still on the mend.

I want to believe what you desire and need
and all you expressed at the start.
You deserve to be loved like never before
and the emptiness filled in your heart.

I wish I could take away the pain that you feel
and right now, have you here so I can touch your face.
For now I have to step back and try to smile,
until your thoughts are in a better place.

You must understand that this affects me too,
and how I long for us to be okay.
Heal your mind, your body and soul
and realize that I am here to stay.

- LM

Love Not Returned

I heard that you love someone,
sadly it's not me.
I hope that you'll be happy,
we'll just have to wait and see.

I'm sure you will be thrilled
if it's the real thing.
I hope you're not disappointed
if it's just a passing fling.

I have no hard feelings
for the choices you have made.
But I would have been so happy
if you had opt and stayed.

One feels really down
when their love is not returned,
but through all the sorrows,
there are lessons to be learned.

- JM

Broken Indefinitely

You can't trust in a broken man,
he can't even trust himself.
He'll want you and he'll need you
but he'll put you on a shelf.

You can give him everything he longs to have
but he won't know how to take it in.
You can try your best to understand his pains
but you don't know where his heart has been.

He doesn't want you to go away
as you can temporarily fill his void.
But he cannot keep you around for long
when his thoughts have been destroyed.

As you give your all to win his love,
you are faced with some form of reject.
He'll be struggling to keep you near to him
while fighting to somehow disconnect.

You try to analyze his thoughts
and why his feelings are so mixed.
With all the loyalty and help you give,
his confused mind may never be fixed.

You can hope and pray that he'll see the light someday
and accept love in his heart and soul.
He's the only one that can make that choice,
to remain empty or finally be whole.

- LM

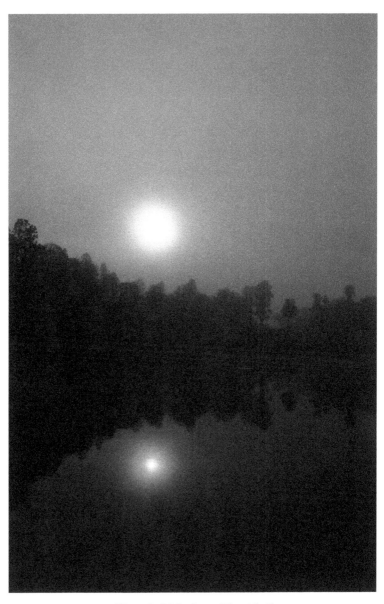

"Land O' Lakes, Florida"
Photo by Lisa Manale

Fading Away

I think of you at bedtime
and in the morning when I awake.
Sometimes I feel my heart smile
and sometimes I feel it ache.

I don't know what to think anymore,
you no longer make time for me.
I do my best to keep in touch with you
as you bow out so casually.

You say you want our friendship,
that it's something you desire to keep.
You once wanted so much more from me
but I suppose for you, I am too deep.

As I try to strengthen the contact
and remind you of the memories we made,
All I can do is sit back
and watch this connection slowly fade.

Slowly fade away...

- LM

The Finger

The other day I happen to run into
a girl that I once knew.
We were together for sometime,
maybe a year or maybe two.

Because we dated for sometime,
I thought it would continue forever.
Then one day she sat me down,
to have a family get together.

I said there was no way
I could change my way of life,
and the last thing I was looking for
was a family or a wife.

Every time she would bring up the subject,
I would just nod my head.
She finally had enough of me,
and walked out....there was nothing said.

But several years later, I saw her once again,
I wanted to know was everything okay.
But before I could utter a single word,
she gave me the finger and walked away.

- JM

Honeymoon

After celebrating our marriage, one of the happiest memories
I have was waking up next to my wife.
This woman, once a stranger, had promised to stay with me
the rest of her life.

I just kept looking at her sweet face
as she lay next to me
and I was thinking, she could've married someone else
but I was the one that took the knee.

I got out of bed and went to make breakfast
and just let her sleep for awhile.
When I told her breakfast was ready
she got up and greeted me with a smile.

After breakfast we dressed and went to shops
not far from the hotel.
Then after lunch we decided
to walk on the beach for a spell.

Since that special time,
years ago have passed.
The love we have shared with each other
has made our marriage last.

We have a nice family
and will celebrate our anniversary in June.
And once in awhile we look through our scrapbooks
and enjoy the photos of our honeymoon.

- JM

Spot and the Shoe

We dated for a month or two
before she finally moved away.
But I will tell you her dog that I can't forget,
even till this day.

We spent the weekend together,
got comfortable and removed our shoes,
then we had something to eat
while we watched the late news.

In the night I heard the dog making growling sounds,
so I asked her what's up with the noise?
She said, oh that's just Spot
playing with one of his toys.

When I was getting ready to leave in the morning,
I could only find one shoe.
But I'm telling you this, when I came in,
I know that I had two.

She told me to look under the sofa,
it's probably stuck under there.
So I looked and then I told her
I couldn't find it anywhere.

When we walked into the kitchen,
it was there on the floor.
Well there really wasn't much left of it,
because it wasn't a shoe anymore.

It was hard to believe
this was once a nice shoe,
had now become a toy
that Spot wanted to chew.

She said she was really sorry
for what her dog had done.
I told her to forget about it,
Spot was only having fun.

As I was walking to my car,
she couldn't stop from laughing,
for everytime I took a step,
my left shoe kept on flapping.

- JM

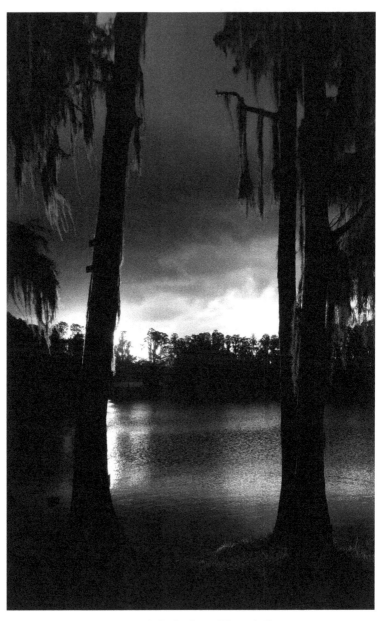

"Land O' Lakes, Florida"
Photo by Lisa Manale

Mutually Blind

I never thought the day would come
that you and I would end.
I never thought it was possible
that I could lose my best friend.

I never knew you were struggling
and that your heart was not in all this.
I never knew I wasn't fully reaching you
everytime we'd kiss.

I never knew that helping you,
would empty all of me.
I never knew your eyes would close,
and that you could not see what I could see.

I never knew how much pain you buried
and how much more you had to heal.
I never thought you'd turn away from me
because of something you don't feel.

I never thought you'd change your thoughts
or forever change your mind.
I always thought my efforts
would help you from staying blind.

- LM

It's Been Over

You did it...
you walked out of my life the other day.
So choked up with tears,
I didn't know what to say.

I always tried to believe
that we would be just fine,
but I shouldn't be surprised,
it was only a matter of time.

I couldn't make you happy
no matter what I tried.
I'll have to move on and accept
that the love we had has died.

Goodbye.

- LM

Missed Opportunity

You never really miss someone
until the moment they are gone.
I thought we would be forever,
well I was sadly oh so wrong.

Years may pass but the memories will last,
no matter the time that goes by.
Certain thoughts will sometimes hit me,
and yes, I will cry.

All of a sudden, with my eyes full of tears,
I'm all choked up missing someone so dear.
So many things I wanted to say,
I should have said them when they were here.

Well all I can say is Goodbye...God Bless.

- JM

Cross Communication

All people who have been dating for a time,
should talk of what their plans in the future will be.
Just sit down and have a nice chat,
being honest is the best you'll see.

They may want one thing
and you may want another,
and their could be several problems
if you don't agree with each other.

Are both of you looking towards marriage
and buying a home?
Or would one of you prefer a career
and doing it all alone?

She asked what I thought of living together
and also sharing the expense.
She explained we would only pay half of all the utilities
and of course, the rent.

After I gave her idea some thought,
I said the situation sounds okay.
So she got her belongings together
and moved in the very next day.

She kept a really clean apartment
and cooked some really good dinners for me.
I knew this wouldn't be a deal breaker
but she made absolutely the very best tea.

But things didn't work out for us
over the years,
and what started out with so much passion
ended up with alot of tears.

That's why I say get everything out
so there won't be any surprise.
Then you can both make a clear choice
on being together the rest of your lives.

She wanted a marriage and family
and I wanted none of the above.
So just sit and talk about all that you can
with the one person that you love.

- JM

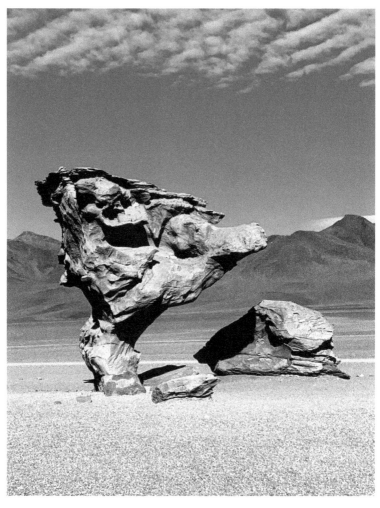

"Uyuni Salt Flat, Bolivia"
Photo by Jeff Hartzog

Not Ready to Marry

Girls were never angry with me
when we would end our romance.
Disappointed, yes, and sometimes tears,
saying I was afraid to give marriage a chance.

I would ask them to move in with me
and even promised to pay for everything.
But they all said, the only way this could be,
is if I would give them a ring.

I just don't want to marry right now.
It's not that there's anything wrong with me.
Maybe I'll get married later on someday,
we'll have to wait and see.

- JM

Merry Go Round

I sometimes think relationships
are like spending a day at the fair.
From the different rides, the shows and all the attractions,
there are choices everywhere.

I often compare a romance
to a ride on the merry go round.
Just like the animals you sit on,
emotions go up and down.

Just remember as the ride continues,
you're just going round and round.
So if someone doesn't feel the same as you,
there is no love to be found.

They just can't wait to tell you they love you
and then they say the love is no longer there.
And you know when it comes to one's emotions,
change is always in the air.

Just like a ride on the merry go round,
your failed love will come to an end.
But if you decide to go for another ride,
maybe a new love will begin.

- JM

Once is Enough

Of all the women I have known over the years,
a few of them wanted to marry a guy like me.
But the rest of the women
never saw any marriage material, you see.

Maybe because I had been married once before,
and that came to an end.
And that's why I am so cautious,
I don't want that to happen again.

The two girls that came so close
with me tying the knot,
wanted two or more children,
and to me, two children are alot.

But I still say having children
is so wonderful and very nice.
And with all the joy and excitement,
children come along with a price.

But the most important thing
is to take care of family when there are needs to fill.
There will be diapers, the nursery, a babysitter
and the doctor to call when they're ill.

That's why the thought of marriage again
is a little scary, you see.
I alone must think this through
to decide which choice is best for me.

- JM

Battling Cancer

It's difficult to convey all that I went through,
friends that faced this fight understand this too.
So much you never realized, the words, the shock, the
fears,
you can't wrap your head around the news as you start off
with just the tears.

It's an uncontrollable mind destroyer,
is the way I put it best.
Along with your body, spirit and soul,
your life is put to the test.

You feel you're pushed in a corner
as the doctors sit and wait for your choice.
You feel like you don't know what's best,
you just want this decision to end with rejoice.

The battle is not just about killing the cancer,
it's about how to get through each day.
You spend every moment in confusion,
working through your thoughts of dismay.

You learn so much going through this,
to describe, it's one big mess.
You feel lost in what's happening to you,
you're faced with anger, pain and distress.

You try to understand
so much of the unknown.
Sometimes you want a friend near you,
sometimes you want to be alone.

As you go through treatments with hesitation,
your body begins to fight.
As you mentally begin to break down,
you tell yourself you will be alright.

The loss of your hair is temporary
but the site still messes with your head.
To look in the mirror and see yourself,
these are moments you start to dread.

Your emotions begin to take over,
as you cry yourself to sleep at night.
You're scared and pissed all at the same time,
relying on the little energy you have to win this fight.

Going through this changes you,
in so manys, it's hard to explain.
Surviving it may be a milestone,
but who you become will never be the same.

Once you've overcome this struggle,
and celebrate that you've defeated this ride.
you do your best to help others,
as they will undoubtedly need you by their side.

People would say I was courageous,
but this has nothing to do with being strong.
You can be afraid in the decisions you make,
only when you think about staying alive all along.

- LM

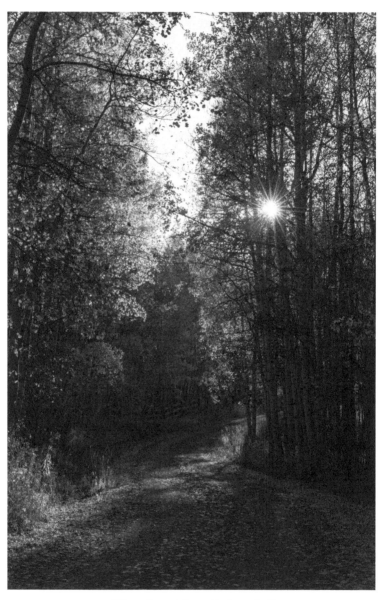
"Breckenridge, Colorado"
Photo by Myra Baldwin Thiessen

Unanswered Questions

I woke up with you on my mind today.
There's still so much I want to say.
You're not in my life the way you used to be.
Don't you realize it's still tough for me?

I don't see you at all anymore,
it's been quite some time since you've walked through my
door.
I think of all the moments we used to spend
and the heartfelt messages you used to send.

I smile when I think about the fun we've had
and now when I think of us, I'm left feeling sad.
I want to ask you if there's anything you miss,
I want to tell you not to forget our first kiss.

You'd express how much I mean to you.
I can only hope every word was true.
You say it's not personal, that you're not in a good place
right now.
I'll keep reminding myself that I'll stay in your life
somehow.

- LM

Words Are Not Enough

You say you like to hear my voice
but rarely call me on the phone.
You say you're always there for me
but many times I feel alone.

You say I am a pretty girl
and love the looks upon my face.
I wonder what I do not have,
you say that is not the case.

You say how much you enjoy our time
but have never asked me out.
You tell me not to take it wrong
then wonder why I doubt.

You say I mean the world to you
but moments you turn to ice.
I beg to hear those words each time,
for my heart it will suffice.

You say our talks are special to you
priceless, we both agree.
But you've never reached out on your own,
it's confusing, can't you see?

You say you respect me to the utmost degree
for the beautiful soul that I am.
Then my thoughts go unanswered, avoided or feared,
as I do the best that I can.

You say that I give you different things
that you have never had.
Then I wonder how you can't want me
and it leaves me feeling sad.

You say you need me in your life
as you sit and hold my hand.
Then you fight to not to let it show,
although you know that I will understand.

You say you'll never leave my life
and that our connection will always be.
Then I feel you pull away
and no effort to come and see me.

You know I understand your heart
and why you have a wall.
You cannot give the depth I do
but you know I will give my all.

So please understand the love that I have
and why I am this way.
I'll never give up standing by you
and pray that God opens your heart someday.

- LM

Remember

Remember the first time you came over
and the long hot moment at my door?
Passionate kissing and touches
left us both wanting so much more.

Remember the time you drove across the bridge to see me,
first time at midnight Christmas Eve?
Our hearts were racing with excitement,
it was so nice, you didn't want to leave.

You came over again just a few days later,
for the new year, you wanted to be back at my place.
You didn't mind the time we spent,
just to see my smiling face.

Many more visits would follow,
once, sometimes twice every seven days.
The talks, the laughs, the kissing and more,
we were always feeling amazed.

You would tell me how seductive I was with you
and how it was difficult to sometimes say no.
You made it easy to express myself
and all that I wanted to show.

From dress up surprises and giving to you,
you were happy when you left my home.
Our memorable phone calls so hot with desire,
would make us feel good when we were alone.

There was always a need and desire to have you over
to enjoy your nights at the retreat.
Just to be in each other's company
is all we needed every time we'd meet.

From funny notes, good music playing
and your cold beer ready for you.
The look in your eyes, the touch of your hands,
I knew that you wanted me too.

These are the moments, always on my mind,
the good memories every time that we met.
It's important to remind you and ask you as well,
to please not ever forget.

- LM

Love Goes On

You may lose the person you love

but you never lose loving them.

You never realize how much you miss them

till they are going, then gone forever.

You miss their laughter, their voice

but most of all, their being.

Knowlingly, you may never see them again.

- JM

Constant Confusion

I know that you don't love me,
you say it time and time again.
I sometimes want to ask you
if you even love me as a friend.

You rarely have your wall down,
I often wonder if it will ever be gone.
I fight to understand you
and ask myself what I've done wrong.

You say I give you something,
that you have never been shown.
Sometimes you seem to need me
and then times you want to be alone.

You say you want me okay
and that you will help me through.
I'll feel your caring heart a moment,
then I'm back not knowing what to do.

Sometimes I'll feel I'm important to you,
while at times it's as if I don't exist.
You may not care about losing me,
But I promise you, I would be missed.

- LM

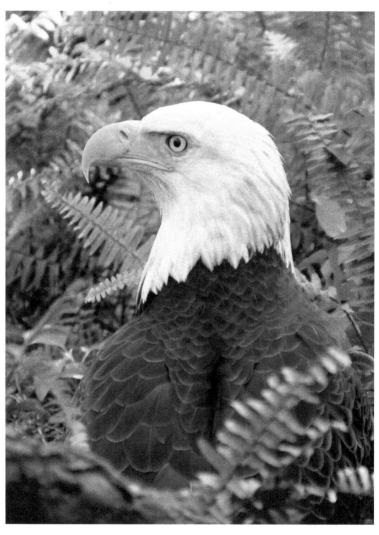

"Bald Eagle, Florida"
Photo by Lisa Manale

Soldier's Legacy

I joined the army a few years ago,
it was just something all males in my family did.
My father, my uncles, it was a tradition,
I was told this since I was a kid.

We were all so very lucky
that no one was ever injured in any way.
We all must've had a guardian angel,
well that's what my mother would say.

Others weren't as lucky, many of my friends were wounded
and yes, a few of them died.
I know soldiers must go on fighting anyway,
but I can't tell you how many nights I cried.

These soldiers are the real heroes
and the reason our country is free today.
For these young men gave their lives,
a sacrifice that no one can ever repay.

- JM

Emptied Effort

I ask myself every single day,
why do I keep holding on?
You keep pushing me away, a little more each day,
I don't think it matters to you if I'm gone.

I cry myself to sleep at night,
wondering why you are so angry with me.
I've tried to keep you so happy and calm,
but it's a way you won't let it be.

I tell you that you can talk to me,
about your pains you have deep inside.
Maybe you don't know how to share them with me
or maybe it's your damaged pride.

When you look back I want you to say to yourself,
"she only wanted to help my heart."
Not that you think I made it bad,
as you tear this connection apart.

You can't give up on people that matter
and that give their all by showing they try.
Instead of making an effort to keep me in your life,
you want the easy way out by saying Goodbye.

- LM

Inner Battle

I am a voice of reason
for the days that your life seems distressed.
Release the anger, fight through the pain,
I will help you and do my best.

I know you have thoughts that maybe you've failed
while you are doing all that you can.
Never regret the choices you've made,
these trials will make you a strong, better man.

We all long for the acceptance, security and love
to fill the voids supressed in our mind.
Difficult to face and uncomfortable to fix,
but when done, true happiness you will find.

My selflessness, compassion, understanding and love
are my gifts that I only want to give.
Once you realize and trust and appreciate all that I am,
You will finally embrace this life that you live.

- LM

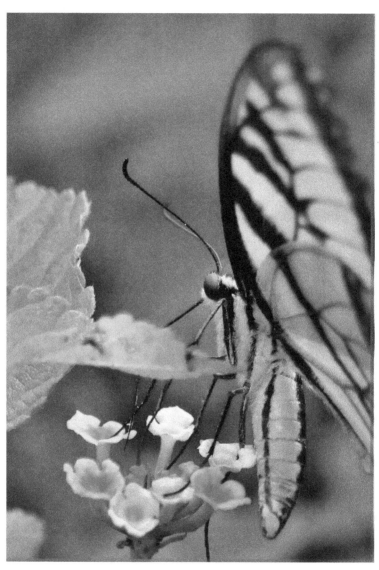

"Eastern Tiger Swallowtail, Florida"
Photo by David Minter

Life Is Beautiful

We all know there is so much wrong in the world these days,
but it's nice to know, beauty still exists and will always.

Open your eyes and ears, listen and look around.
There is almost an endless amount of beauty to be found.

All life is amazing, flowers when they bloom, leaves
turning green on a tree and of course, you and me and all
humanity.

There are things you can't see but you still know they
are there.
You can feel the raindrops on your face and the wind
blowing through your hair.

There is also beauty to be found in family.
The miracle in the birth of children, watching them grow
up and share all things of beauty they see.

Surround yourself with all that is beautiful in life because
someday all life will go away.
So enjoy your family, your friends and all things of beauty
every, single, day.

- JM

Depleted and Defeated

I have given you every part of me...

From my mind, I have expressed to you what it takes to heal yourself and make your life better but you no longer hear me.

From my body, I have shared deep intimacy and passion and the importance of physical closeness but you've chosen to forget those moments and no longer touch me.

From my soul, I have given and shown all the care, loyalty and love to fill your empty heart but you didn't want it.

I've tried for so long to teach you understanding of what you cannot see, but you no longer appreciated me.

You took all the good from my heart that I so willingly gave and once I was empty, you no longer needed me.

You've turned away from me and all that I am and have left me with nothing.

I think I'm finally giving up as all of my efforts seem to go unnoticed now and thrown away.

I give up....and now the real pain begins of letting go.

- LM

Soon

I long for your touch
in my loneliness today.
Your heart is right here with me
but your body is far away.

I close my eyes and imagine
that my head is on your chest.
You brush your hand across my hair,
these intimate moments are the best.

As we both wait so patiently,
for that hug and that very first kiss,
the only thing we both long to feel,
is passion, comfort and bliss.

I can't wait for you to show me,
that you're not like other guys.
Looking forward to the moment
we first look into each other's eyes.

Let's keep learning about each other,
I'll give you all, my dear.
It won't be that much longer,
and you will finally be here.

- LM

I Ask Myself

I ask myself how can it be this way,
two hearts that are filled with good.
With only love to give in this special bond,
why is it so misunderstood?

I ask myself why you seem to hate me so,
at times when I need my friend.
Our words get lost and turned around,
and then you want it to end.

I ask myself what I didn't do,
to please you in every way.
I gave my all wholeheartedly,
but not enough for you to want me to stay.

I ask myself why decisions are made,
fueled with anger, fear and pain.
Then you comfort me to ease my mind,
as I believe I will never see you again.

I ask myself if I've touched your heart
so I can live knowing I truly did so.
You say I give you something different indeed,
so please don't let me go.

I ask myself how my life has been changed
believing you are the man of my dreams.
But the dreams have been ripped away from me,
I guess nothing is what it seems.

I ask myself how to get through this all
and for God to take away my pain.
You affected my life and have my heart,
my days will never be the same.

- LM

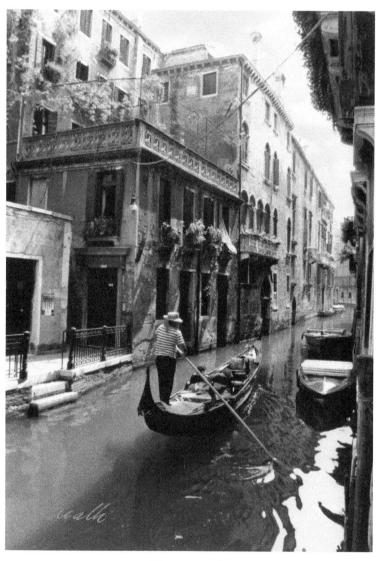

"Venice, Italy"
Photo by Al Picallo

Different Dreams

From the moment that we met
and until the very end,
I thought she was the one I'd love
but these things happen now and again.

People change over time
and so do most of their dreams.
But her dreams and mine were oh so different,
there's no way either would be seen.

You must go your way
And I must go mine,
and whatever it is you're searching for,
I truly hope you will find.

Maybe we will be together just once more,
but I feel our future is dead.
I think my mind is playing tricks on me,
forget all I have said.

- JM

Getting Through Their Final Journey

Taking care of a loved one
who's health will only decline,
no matter what they're facing,
you always wish they had more time.

You feed them and you dress them
and things you thought you'd never do.
Helping them walk to the bathroom
and giving them showers too.

They look on their face, the fear in their eyes,
the thought they can't take it anymore.
You try to give them hope with encouraging words
but the truth just rocks you to the core.

Their battle affects your mentality,
in ways you don't want them to see.
You do your best to put on a good face
even though you know how it will be.

You're confused and angry, bewildered and sad
as uncertainty becomes so intense.
You're consumed with anxiety, questioning why,
finding answers of it all to make sense.

You talk to them about the good times
and remind them of moments that you've shared.
One thing in common at this difficult time
is the fact that both of you are scared.

You always wish you could do more
as they struggle and you stand by their side.
You hold back your tears to show you are strong
when truly you are dying inside.

As you hold their hand and hope they can hear you,
you painfully wait for them to drift away.
You just want them to no longer suffer
but crushed that they cannot stay.

The challenging experience, the heartbreaking toll,
you were not prepared for this test.
All you can do is remember what you've learned
and that you did your very best.

- LM

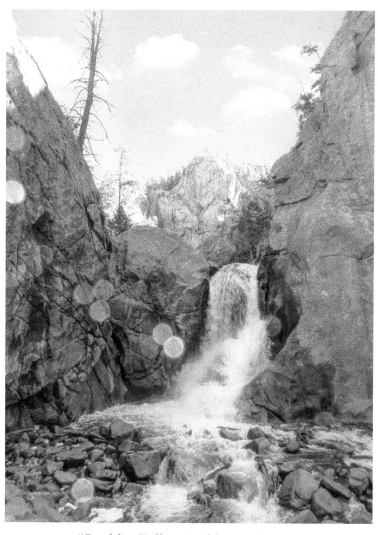

"Boulder Falls - Boulder, Colorado"
Photo by Lisa Manale

I Want to Forget

Well it's finally over,
our love affair has finished.
What was once a glowing flame,
has finally diminished.

Six long years of happiness,
has forever gone away.
I just don't know what happened,
it still puzzles me today.

And yet maybe tomorrow
will bring me a love that's true,
then I finally can forget
the pain of losing you.

- JM

Gold Digger

I really enjoyed our first date,
this girl was attractive, smart and funny.
However I did notice that after a few drinks,
most of her conversations would be about money.

I guess it's normal,
that alot of people want nice things,
but until she found a rich guy,
I would just be one of her flings.

Alot of men want to date pretty women,
we all know this is true.
But if her first love is money,
the future may not be good for you.

I never met anyone
so obsessed with being wealthy.
It seemed she didn't care if the person she married
was sick or very healthy.

When she drank too much, she always talked about
marrying a guy with plenty of cash.
I think people who are selfish and care only about themselves,
are nothing but worthless trash.

After awhile I stopped seeing her,
and surprisingly she asked me why?
I said you're only wasting your time and mine,
I'm not a wealthy guy.

- JM

The Jerk

She thought she was in love,
her friends said it would never work.
For she was beautiful and intelligent,
and he was, how can I put this...a complete jerk.

Their marriage lasted a month or so,
then it came apart.
She said it was all a big mistake,
should have thought with her head and not her heart.

You see, she was a cheerleader,
he was on the football team.
It looked like they would be great together,
but sometimes things aren't what they seem.

She finally ended up
with a really nice guy that she had found.
For she knows the first guy that she married,
was nothing but a clown.

- JM

You and Me

It was our love of animals,
how you and I met back then.
You would become my mentor and my lover,
my rock and my true friend.

I was only nineteen
and I so much looked up to you.
You seemed to have all the answers,
your integrity was real and true.

Our connection was instant,
so amazing in every way.
A bond that would strengthen over time
and solidify what we have today.

We knew we couldn't be together,
as other obligations kept us apart.
It was okay if I couldn't see you,
what mattered was what's in our heart.

Over the years there were moments of silence,
where life had us somehow lose touch.
You were never far from my mind,
and my thoughts of missing you so much.

The sound of your voice brought me comfort,
so many times that you'll never know.
I still long to hear you talk to me,
and reminisce about so long ago.

The love I have for you is like no other,
it is beyond what words can explain.
Throught life's ups and downs and uncertainties,
our special love will always remain.

I smile when I think of our memories,
and wonder if there's a chance or will it never be?
Whatever is meant to happen between us,
there will always be a you and me.

- LM

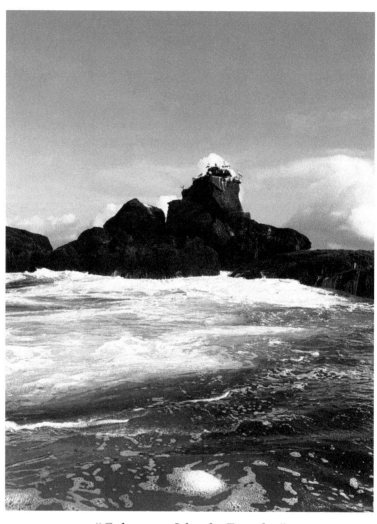

"Galapagos Islands, Ecuador"
Photo by Jeff Hartzog

Selfless Love

I met Nancy years ago and asked her out to lunch.
After food and conversation, said she was glad that we met.
Then I asked if she would see me again and wow, the
answer was yes.
We had a really lovely evening, one I'll not soon forget.

She had a natural beauty,
pure intelligence and class.
All the things most people want
but very few of us possess.

To me, she was perfect,
I still feel that way in my heart.
Although I know this fantasy
can quickly fall apart.

And I must tell you this,
She was the most selfless person I had ever met
She once gave a sick little girl
her very own beloved pet.

I knew I would fall in love with Nancy
it was just a matter of time.
She also said that she loved me
and everything seemed fine.

We took long walks together,
sharing dreams we'd never see.
I just couldn't make a commitment to her
so Nancy set me free.

- JM

All Go Suddenly

I remember the day you reached out to me,
it was so sudden and unexpected as well.
I felt flattered that you wanted to talk to me,
and it seems you needed my friendship, I could tell.

We spent hours sharing personal thoughts,
and of all that we have been through.
It was refreshing to know I connected with you,
and that we understood each other's fears and dreams too.

We felt so alive with our comfortable laughter,
and our sensual talks we had on every call.
I felt at ease with your voice and the words you expressed,
reassuring me I could let down my wall.

You said all the right things and how I was your light,
you pursued me as you came on so strong.
How could I have known that everything I believed,
was just an exciting moment that wouldn't last long.

A sudden change happened for you,
as you realized you weren't ready to love again.
As quickly as I found trust and hope with you,
the promises and plans we had came to an end.

The compassion in me wanted to be there for you,
and show my loyalty and stay by your side.
What you once welcomed so much from me,
you pushed away so you could quietly hide.

Then suddenly you reached out again,
to make it clear you had changed your mind.
I was baffled and hurt as we wanted to give this a chance,
not thinking there would be someone else you would find.

You were always looking forward to talking to me,
just to hear my voice as you reached out every day.
Then you called me to tell me that all I've shown, which
had never changed,
was now driving you away.

As I try to understand your struggles in this,
and the reasons you no longer want me and why.
You say you still want me in your life as a friend,
but your actions are telling me goodbye.

For now I will cherish the good moments and smile,
with the strong desire we had just on the phone.
As you start to avoid me a little more each day,
you've made your point, I will leave you alone.

- LM

Signs of the Time

The world as we know it
is spiraling out of control.
The evil and the sickness
is taking its toll.

People are dying,
so much of it out of hate.
Can we pull ourselves together
before it's too late?

Many have taken ill
as diseases consume moments we're here.
To not resolve or cure the impossible,
leaves us constantly living in fear.

Wildfires are raging
and depleting the land.
Disaster after disaster,
it's all out of hand.

Countries fight each other
just to see who can win.
It's been this way since the start,
and it will undoubtedly happen again.

The end days are happening
as we've already been told.
So as you live day to day,
watch as the prophecy unfolds.

- LM

Time of Healing

I hate to hear when you're not feeling well,
it makes my own stomach ache.
I worry if your heart is strong enough
and how much more that you can take.

Sometimes when your emotions are struggling,
it affects the body too.
Hinge on all that's positive
and only what is true.

Your days may be filled with hope
but certain thoughts bring you to tears.
Let me be the one to open your eyes
and erase all of your fears.

I want your days to be brighter
as I fully give you my light.
The time for your happiness will prosper
as the sadness is gone out of sight.

- LM

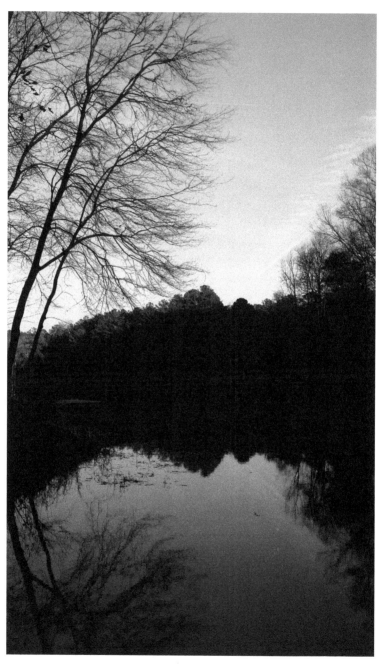

"Abel Lake, Alabama"
Photo by Lisa Manale

Today I Want To Tell You

Today I want to tell you
that this life we have is not long.
Sinking from pain, fighting to swim,
focusing on what makes us strong.

Today I want to tell you
that loyal people are special and rare.
Giving their all, sparing no thoughts,
anything to show that they care.

Today I want to tell you
beautiful hearts are hard to find.
Battled and broken, yet blessed to stay whole,
what's inside is one of a kind.

Today I want to tell you
that real passion feeds the soul.
Affecting the body, the heart and the mind,
without it, the hunger takes its toll.

Today I want to tell you
that real love is misunderstood.
Through desperation and desire, a need to have it all,
we overlook the one who truly could.

Today I want to tell you when the heart can't stop giving,
it can feel foolish and sometimes some shame.
Understand the depth, value the truth,
and realize no one could love you the same.

- LM

Give It A Chance

Please don't hurt me
or shut me out,
I want to know so much more
of what you're all about.

I felt each day we were getting closer
but it's now seemingly strange.
I've enjoyed so much of the talks and laughs,
it's something I don't want to change.

I want us to hold on
to this special friendship we've gained.
You've done something to me in such a short time,
something I can't explain.

I hope to continue to be each other's light
and help each other through day to day.
I need to know you're not going anywhere
and from me, you won't slip away.

- LM

Vulnerable Depth

I may be a very deep hearted soul but I am not complicated.

I may have endless words and get excited when I talk but I do have my moments where silence takes over and I don't know what to say.

There are times when I worry because I care but many times I am completely confident that everything will be okay.

I sometimes break down and cry when I'm sad but it doesn't mean I'm weak or hopeless.

I'm not perfect and I have needs too but I also love to give and go out of my way to give you what you need.

I rarely notice anyone's faults because I'm too busy focusing on the good inside of them.

Once in awhile I have questions because of my confused mind but I am the most understanding woman you will ever know.

There may come a time where we are both at a loss for words but I make it so comfortable to communicate with what's on our minds.

At times my soft heart hides behind an unbreakable wall but I can also hand you my heart because I feel safe and no wall is needed.

I may be scared in trusting to love again but when I know someone is worth it, I have no doubts and I completely lose sight of getting my heart broken.

- LM

Forever Guarded

Why do we have these fights when we only want to feel love?
Have we forgotten our answers will come from God above?

Why do we let the anger act on every troubled thought?
Have we thrown aside all the good that we were taught?

Why it is always the stress that consumes us in every way?
Don't we realize our time is a gift and that it will all be
gone someday?

Why do moments of sadness grow into hopeless despair?
Why can't we always remember that the key is showing we
care?

Why is fear such a constant sometimes controlling the life
that we live?
How can we ever overcome it if we can't accept what one
has to give?

Why do we shut down emotions and build walls to keep out
the pain?
Haven't we learned without risk you'll stay in the dark with
nothing to gain?

Why do we forget our heartaches can be healed and
nurtured to grow?
Instead we die with an emptiness for rejecting a love that
we'll never know.

- LM

No Second Chance

Since the day we stopped seeing each other,
I've had this emptiness inside.
I have never been in this position before,
so my feelings are difficult to hide.

I don't think any person is really happy
when a romance like we had ends.
And after sharing passionate love with you,
there is no way we can ever be friends.

If you were to call and say you're sorry,
it was all one big mistake,
well I would never take you back again,
one broken heart is all I can take.

The next time I get seriously involved,
I hope she really wants love with me,
but for now, it just feels good
to be unattached and free.

- JM

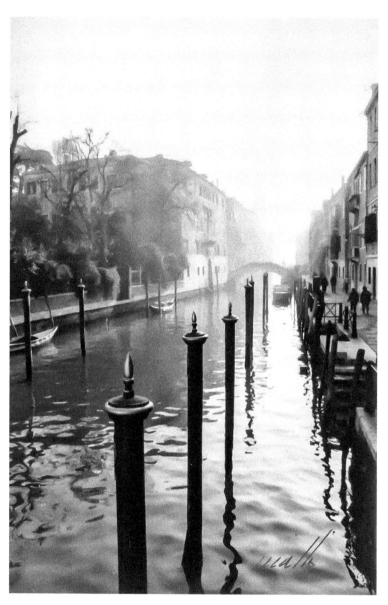

"Venice, Italy"
Photo by Al Picallo

Disappointed

Though many years have passed
since you went away.
I still think of you often,
almost every passing day.

But there was always hope,
in my heart it seems.
But hope has gone away,
along with all my dreams.

I thought that you still loved me,
and that we would stay together.
But then I finally realized
that nothing lasts forever.

- JM

Matter of Age

I don't know if you've ever been involved
with someone much younger than you.
And we all know this is something
alot of older men do.

I know it makes a man feel good
to have a young lady on his arm.
But is she looking for security
or could it be he just has a lot of charm?

I met this young lady at a party
and she was only twenty five.
And just sitting next to this attractive woman,
made me feel alive.

We shared interesting conversation,
she was really in the know.
It was really hard to believe
she graduated college three years ago.

Before I asked her to have dinner with me,
I felt there was something she had to know.
And when I whispered my age to her,
she just laughed and said, that's not old.

After seeing her for several months, she told me she loved me,
I said well, I love you too,
but we have a real dilemma here,
I'm twenty years older than you.

Looking at me straight in the eyes,
she said, I'm telling you I really don't care.
I replied, I know you're sincere with what you're saying,
but there's one thing you must be aware.

The years will fly by,
and believe me, this I know,
and while you're still young and pretty,
it's your husband that will just be old.

- JM

Irreparable Darkness

Sometimes I think of my time with you
and how there were more bad times than there were good.
Why I allowed so much to happen,
is still so misunderstood.

I did my best to get you through your dark days
and for that I would never regret.
I try to remember only the fun that we had
and the toxic memories, I want to forget.

I fed you and I clothed you,
I put a roof on your head.
And there was never any gratitude,
only horrible things that you said.

I tried to help you away from your addictions
and to better understand your pain.
I gave you all the support I possibly could
but you'd give into your demons over and over again.

You claimed how much you loved me
but the way you treated me did not say that at all.
You would disappear for days at times
until you needed me, then you would call.

The rare moments that you were sober
and before the withdrawals would take their toll,
I saw a different person in you,
a sweet and loving soul.

I finally built up my strength and will
to leave you as I knew I should.
I lived with guilt for a short time after,
wondering if I did all that I could.

To get over what had happened with us,
it was best for me to stay away.
I'd hear how you were doing through others
and that you were making through okay.

When I got a call from your mom one day,
I knew that something was very wrong.
With tears and pain in her broken voice,
she told me that you were gone.

I sometimes question if I only prolonged the inevitable
and how this all happened and why.
The only regret I have with you
is that I didn't get the chance to say Goodbye.

- LM

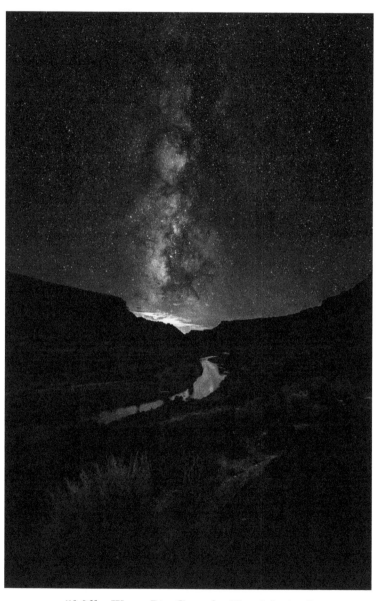

"Milky Way - Rio Grande, New Mexico"
Photo by Myra Baldwin Thiessen

I'll Always Wonder

It had been a few years
and I saw you on the road today.
I thought I had gotten over you
but I realized nothing had gone away.

I wondered if you were still angry with me
although I was sorry that I hurt you so.
I wondered if you had forgiven me
for what happened long ago.

I remember the last time we were together
as we cried with your hands on my face.
We knew we could not be together
but you in my heart, I could never replace.

I think about how you are doing
and if you wonder too how I've been.
I wonder if we'll see each other's face once more
or if I'll never see you again.

I hope our memories never fade from your mind
and that you healed with us torn apart.
I hope you still smile when you think of me
and how much you loved my heart.

In the meantime I'll hold on to the good that we had,
every moment I will keep close to me.
I pray someday you'll be back in my life somehow,
I'll just have to wait and see.

- LM

High School Crush

I was sixteen when I first thought it was love
and I know alot of teenagers have a first time love story too.
It all started the first year
of the three I spent in high school.

I was a little nervous
going from grade nine to ten.
Then everything went back to normal when walking
towards me,
I saw a junior high school friend.

We were all excited because
we were doing something new.
We didn't feel like kids anymore, we had grown up
and we were starting high school.

I remember my old seventh grade class, I would say hello
and talk to a cute little girl named Gwynn,
but when I first saw the eighteen year old majorette in her
uniform,
it really put my head in a spin.

In my neighborhood, just a few years before,
we all played games, like spin the bottle.
But since I was now older my thoughts of girls
was going from idle to full throttle.

I knew a real romance between the senior
and myself could never be,
but one thing I know for sure, this particular majorette
was more than just one man's fantasy.

- JM

Crush Unknown

It's been so many years later
and now we're talking about our crushes back then.
You weren't that much older than me
but I suppose we had to pretend.

I was only sixteen
but you were already out of school.
You sometimes had me nervous when I was around you,
but I always thought you were cool.

We knew alot of the same people
and you knew my mom and grandma too.
No one made a fuss back then
when Nana shared her beers with you.

I always wondered about you building my mom's house
and how that came to be.
If our paths had not crossed back then,
there may not have been a you and me.

We never knew our crush for each other
until all these years have gone by.
We don't even notice our age anymore
only that time surely does fly.

- LM

Birthday Surprises

We were having breakfast when she told me
her birthday was just a week away.
I said, this is a pleasant surprise because two weeks from now
I also have a birthday.

We decided to go out for dinner that night
and celebrate and enjoy the evening together.
After dinner, the waitress brought us a little birthday cake
for us to share with each other.

During dinner she asked,
Joe, are you staring at me?
Yes, I said, surrounded by all these people,
you're beautiful face is all my eyes can see.

My gift for her was something
she told me about a few months before.
So on the day she mentioned her birthday,
I left the house and went to the store.

When she opened the small box and saw the gift I gave,
for a moment she didn't know what to say.
I told her, I knew this was something you wanted,
so honey....Happy Birthday!

We really had a lot in common
so I was hoping this romance would last,
but I wasn't going to get my hopes up,
I have made that mistake in the past.

I asked her what she thought about marriage,
just to hear what her answer would be.
Her reply was not what I expected,
it was quite surprising to me.

She said because I'm still young,
a life long relationship would be a few years away.
But falling in love with someone who also loves me,
could also change my mind any day.

- JM

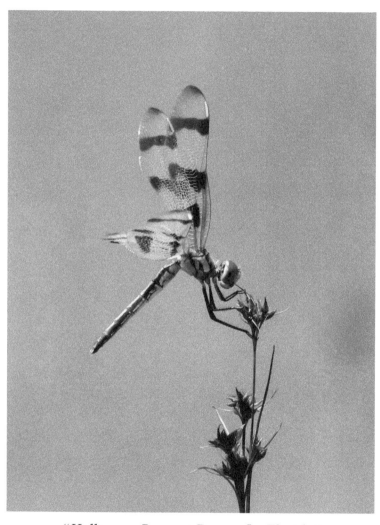

"Halloween Pennant Dragonfly, Florida"
Photo by David Minter

Hopeful Healing

I had a strange sadness
come over me today.
I don't know how to explain it,
I don't know what to say.

I feel the sadness is winning
of you trying to get through your past.
I'm worried about you overcoming it all
or how long it will last.

I do believe your heart is ready to move forward
and truly be happy once more.
But I think your head is still in limbo
and unclear about being sure.

I know deep inside, you're longing to feel whole
and forget about all the bad.
I have no doubt when you're ready,
you'll have a love like you've never had.

- LM

Value Time

As the years go by,
and we live day to day,
the more we get the news
that someone we know has passed away.

It could be family, a lover,
a mentor or even a friend.
You realize those days will come
but it still hurts when it comes to an end.

We immediately think of the memories,
as we smile and then start to cry.
You do your best to block out the "what ifs",
it's not easy no matter how hard you try.

Eventually your days start to get better
and you embrace every moment you're here.
The sad times might hit you so often
but someone will be there to wipe away every tear.

Death has a way of teaching us
to cherish each other and grow.
Each day here we have is a blessing
and our last day...you just don't know.

- LM

Through Thick and Thin

I have several friends,
that their parents have been married more than twice.
I guess they were looking for something new and different
to bring spice into their life.

My friends said it took a few weeks for them
to adjust to someone so new.
Said it wasn't easy
but there was nothing else they could do.

I was very lucky to grow up in a home
with parents that were the best.
They stayed married for life and whatever the problems,
both handled all the stress.

With so much love in our home
and parents that really cared.
Whatever the situation was,
everybody shared.

They also taught us to know right from wrong
and to know good from bad.
Yes, they were both the very best...
my loving Mom and Dad.

- JM

Go Fly A Kite

Many years ago,
when I was at the tender age of fifteen,
and I think you all know at that age,
you sometimes do stupid things.

A group of kids got together
to find something to do.
There was still a few weeks left
before we had to return to school.

This kite had a frame in the shape of a cross
and stood six feet tall.
We made it this size
because we already had kites that were small.

Well we finally finished the kite
and now it was ready to fly.
It was a little windy that day
but there was a clear blue sky.

When the kite finally became airbourne,
What we made was an awesome sight.
You had to hold the cord
and hang on with all your might.

We collected the extra cord we had
and to the original one, we would tie.
We all wanted to see just how high
this kite would fly.

We took turns holding
the kite all afternoon,
but we knew we would all have to go home
for dinner pretty soon.

We all knew it would take hours
to bring in this thing.
We didn't have alot of time so we just got a knife
and cut the string.

- JM

"Weeki Wachee, Florida"
Photo by Lisa Manale

A Special Bond

It truly seems like yesterday
when I think about our first night.
You knew exactly what to do,
You made everything feel right.

The light of glowing candles
and the smell of incense in the air.
Our flirting, talks and laughter,
now so nervously ready to share.

I wanted to feel pretty
with the pink dress that still comes to mind.
We talked and kissed with racing hearts
as we sipped on sweet red wine.

You were anxious but took your time with me
as you showed me to feel loved like I should.
We knew there were secrets and boundaries
but somehow we always understood.

From that day on we were connected,
a rare passion and love that would grow.
If it wasn't for us taking a risk,
this special friendship we'd never know.

The years and miles may pass us by
and every moment we always longed to find.
No matter where life may take us,
what we have is one of a kind.

- LM

Daring Date

We met at an office party,
she was fun loving and kind of wild.
I've always been quite conservative,
doing anything crazy is not my style.

I was a little hesitant
before I asked her out.
But I was more than curious
to see what she was all about.

She enjoyed things like sky diving,
fearlessly leaping from an extremely high place.
I didn't want to join her in any of this,
you could tell by the look on my face.

We only dated for awhile,
because the things she did really scared me.
But you must remember this, she was beautiful
and I had just turned twenty three.

When you're young, you take all kinds of risks,
and you really do feel you're invincible.
But fortunately you do have a choice,
just to just do something sensible.

But finally after all those years,
she stopped doing what she called fun.
For she really changed her life completely,
and then she became a nun.

- JM

Absent When Needed

I thought I was your best friend,
and with everything I've done.
When you think about who has been there for you,
was I not the only one?

I've dropped everything to help you,
in times with your health and needs.
Even at moments when it was convenient for you,
or at times our friendship recedes.

From relationship troubles with family
and so many unworthy men.
I go out of my way each and every time for you
even if it happens again and again.

When you've been depressed and disheartened at times,
I give my all to somehow make you smile.
But when things seem to be going well for you,
you go back to disappearing for awhile.

Very seldom I need you to be there for me
because I too sometimes have lessons to learn.
All I ask is for you to be there when I need you,
and give me what I've given you in return.

- LM

Affairs of the Heart

I was in town when the downpour started
and went into the nearest building to avoid the rain.
I was at the window, she stood next to me, we both said Hello
and that's when our romance began.

I just happened to go in the building that day
where she was employed.
We soon shared lunchtime twice a week,
a little something special, we both enjoyed.

I have only been involved in a few relationships,
the longest lasted six years.
While most of them ended on friendly terms,
this one ended in tears.

Strange things happen when you're in love,
you wander around with your head in a cloud.
You're so excited, you want to tell the others
by speaking up and shouting it out loud.

But all of this can fall apart quickly
if one is not too careful.
Eyes that looked so bright one day,
the next day could be tearful.

She wanted to do certain things in the future,
since we were more than friends.
But we often disagreed with each other
and this was the beginning of the end.

There are certain things people will do
to try and stay together.
But we never saw each other again,
and our love was lost forever.

I really don't think anyone wins
in a relationship that falls apart.
But who really knows anything
when it comes to affairs of the heart.

- JM

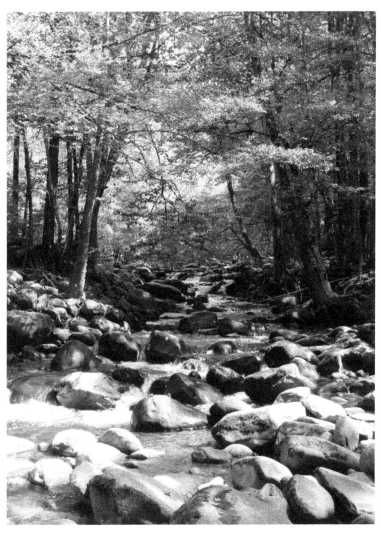

"Greenbriar, Tennessee"
Photo by Lisa Manale

Pain Driven

My heart is breaking, don't you know?

Why do you seem to hate me so?

Can't you see I give so much?

How can you discard this heart you've touched?

I've been so sad and what about you?

Don't you struggle with these things too?

I know you're hurting and so am I.

Why not be there for each other, give it a try.

- LM

Soul Destroyer

I worry about meeting narcissists
as I have met so many over the years.
No matter how wonderful you believe they are at first,
they will always leave you in tears.

You want to believe that someone could adore you
and fall in love so quick at the start.
But all of it is a deep seeded plan
to callously rip out your heart.

You try to find any good you can,
anything that you can tell.
But you're only prolonging the inevitable,
as this person will put you through hell.

You catch yourself justifying their sick behavior
because of their own jaded past.
Don't waste your time and energy
on something that is never meant to last.

They make you believe you are crazy
and put you down when no one's around.
They talk to others about you
making you look like a fool and a clown.

You try to wrap your head around
of how anyone can be so cruel.
You find yourself feeding their selfish needs,
you're not a person in this game, just a tool.

When they've completely sucked the life out of you,
you try so hard to leave.
Find your strength and be prepared
for a war you will not believe.

The abuse will go on indefinitely
and not just with words in what they say.
The moment you know what you're dealing with,
protect yourself and turn and walk away.

- LM

Food For Thought

There are certain foods that I refuse to eat,
like chitlins, boiled okra or pigs feet.

But I'm not the only one with this some sort of disease,
this guy I know won't eat eggs, grits or macaroni and
cheese.

I guess if I was starving, I would eat whatever I could find.
But forced to eat things like head cheese or blood sausage,
would really blow my mind.

I know of people who eat things, like liver, kidneys and
heart.
I have never tried these things and I have no intention to
start.

In Columbia, the lady served brains and eggs at the
beginning of the day.
I thanked her and said I'm sorry, but I have to be at work
right away.

In Korea, when I saw a family eating a dog, I shed a little
tear,
then I was told that Koreans eat a million dogs a year.

We all know that there are people that will eat anything
from a monkey to a bat.
Maybe I just have a weak stomach, but no, I cannot do that.

- LM

Zeno: An Alien Perspective

We had finally entered earth's atmosphere after a long
voyage in space.
Our missions have always been just to observe, and not get
involved with any other race.

After spending time on your planet, this is what our kind
does know...
Compared to other worlds we've seen, your beautiful earth
is just a hell hole.

We have observed alot of dishonesty, hatred, sickness and
greed.
People thinking only of themselves, they care for nothing
for other humans in need.

But we don't judge all of mankind by just these tainted few.
There are plenty of people all over your world who do good
things too.

We've come to a conclusion that there are only a few things
we like with all the ruthless injustice to be found here.

There is nothing but war, diseases and hunger with millions
of people continuously living in fear.

After quietly thinking it over, we have decided not to stay.
It's been an interesting and surprising visit but tomorrow
we will be on our way.

We are sorry to have to tell you this, but there is no way your planet will survive.

I'm going to make a prediction that in just a matter of time, no human on earth will still be alive.

- JM

Dad, Daughter and Divorce

I remember the days when I was a kid
and my parents had decided to divorce.
I didn't understand exactly what that meant
but my dad explained it of course.

He sat me down and told me
that he wouldn't be living there anymore.
When I realized the reality of it all,
it was a moment I could not endure.

I had never seen my father cry
and the first time was that day.
I knew he would no longer be living with us
but that he would never be far away.

From that day on, me and my dad always had a bond,
that brought us closer over time.
We may not have seen each other every day
but every visit was more than fine.

As the years went by, so many memories made,
and all the get togethers that we always had.
I cherish every memory and every wonderful moment
of every time spent with my Dad.

- LM

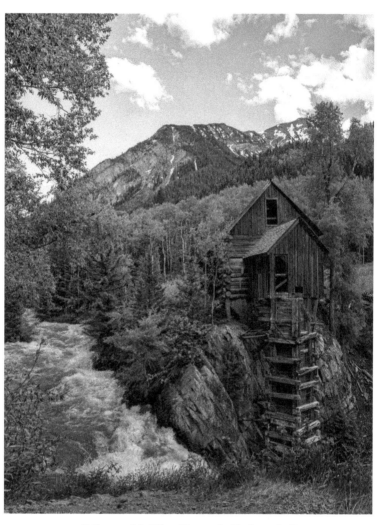

"Crystal Mill - Crystal, Colorado"
Photo by Myra Baldwin Thiessen

Divorce is Difficult

Every day without your family, at times you'll feel lonely,
but your children are always in your heart.
And you really do deeply miss them
when you're miles apart.

But in the end,
it's really the children that suffer together.
Spending a few days with one parent
then going home to the other.

There is no reason to stay married
if all the love has gone.
Even if both of you try to act normal,
the children know there's something wrong.

Sometimes it's hard to accept
that the one you loved is dating another
but this will normally happen
when you are no longer together.

And although some divorced couples
decide to start dating again,
it's really nothing serious,
it's usually only as friends.

I'm willing to fully accept
all the blame of course.
It once was a happy married life
that had ended in divorce.

- JM

Let's Elope

If I ever get married, I hope it's like my mom did
and my grandma too.
The both eloped with the men they love
so there's was nothing anyone else could do.

Things were different
with the way it was back then.
A woman's dad was to be asked permission,
from the love struck men.

For a man to do this,
it was sometimes a little scary.
He had to get approval
for the woman he wanted to marry.

The alternative to elope seemed less stressful,
as your bride would certainly say yes.
So you decide to run away and tie the knot,
to bypass and avoid all the stress.

So instead of asking the Father,
with his possible answer of " nope",
join your love in matrimony,
and take a chance of the choice to elope.

- LM

Mixed Signals

There was a time where you showed me how you felt,
and yes, you were so sure.
And now when I remind you,
you deny your words...or don't remember.

Your desire for me was instant.
We could not help ourselves face to face.
Our hearts would race, our bodies on fire,
These memories.....Do not erase.

You'd say our talks and laughter are priceless,
left you always wanting more.
Now I wonder why you have changed
and if you'll ever come back through my door.

You tell me you're just not ready
and that my heart is filled with good.
I've given you every part of me,
so you turning away is misunderstood.

You say you enjoy our kisses
and still have thoughts about my touch.
I ask myself if I've somehow reached your heart,
or if all along I was only a crutch.

All I've ever wanted is for you to be there
and not lose my friend.
I fight to keep the bond we have
while you fight for it to end.

Please don't turn away from me,
my eyes no more want to cry.
You will need me in your life somehow,
stop trying to say goodbye.

- LM

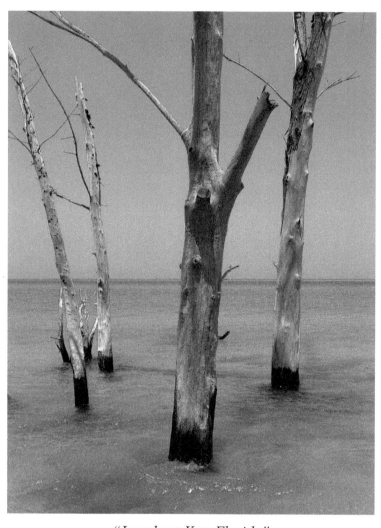

"Longboat Key, Florida"
Photo by Lisa Manale

Anticipation

I can't wait to finally see you,
just a little more than thirty days.
I hope I can make you feel good at heart
and that our time for you is not just a phase.

I enjoy our talks and laughter,
even the hours we spend on the phone.
It's nice to know we can turn to one another,
if we're down or feeling alone.

A little cautious and guarded
and who we trust to let in.
We can both feel comfort in our thoughts,
as we both know where each other has been.

We long to have those priceless gifts...
the passion, the love, the touch.
The more I think about your amazing heart,
the more I want this so much.

I guess whatever happens with us,
we will have to wait and see.
If there's two people that deserve to feel complete,
it's undoubtedly you and me.

- LM

In Fright Flight

I had a dream I was in an airplane that crashed but I needed
to be back at my job the next day and had to fly.
I decided not to worry about the dream, so the next
morning I just told everybody goodbye.

I have traveled by airplane many times over the years
and always felt safe buckled in my seat.
I would always relax and drink
and maybe have a little something to eat.

Some people are nervous so they consume alot of alcohol
on the plane when up in the sky.
They say drinking helps them take away
alot of fears they have when they fly.

That night I was on a flight from Miami to Tampa
after a long holiday,
but the memory of that late night
may never go away.

I was still asleep as the plane was landing
when I heard someone cry out.
I woke immediately and asked
what all the noise was about?

The plane had somehow skidded off the runway
but finally stopped after sliding onto the grass.
At that moment in my mind,
A flash of thoughts came from memories of my past.

Flying is much safer than driving. Yearly,
car accidents cause over a million people to die.
Although hundreds die in one plane crash,
they claim it's still safer to fly.

The pilot told everyone to be calm,
then explained what all the excitement was about.
He said everything is okay,
just one of the tires had a blowout.

I could clearly see the escape slides
as buses picked up everyone from the plane.
I said to myself, I'm not as brave as I thought I was,
next time I'll take the train.

- JM

Bahama Dream

We were flying to the Bahamas for a week or so.
Everything was perfect, too perfect, this I now know.

I thought this would be the perfect time and place to ask
her to marry me, although no man can be sure of what a
woman's answer will be.

After the plane landed, we went to the hotel, checked in
then went to the beach to swim and enjoy the sun. Again,
everything was perfect, no problems, no issues, just fun.

After dinner we took a walk in the bright moonlight.
I felt the time was perfect, it was such a beautiful night.

I got down on one knee, held her hand and said, you know
I love you so I'm asking you to be my wife. She said yes,
you're the one I want to be with for the rest of my life.

The alarm clock went off Then I woke up and knew that
things were not as perfect as they seem. Well, I was right,
the only time things can be perfect are the stories when you
dream.

- JM

Ship Had Sailed

She was smart, attractive and only two years before,
just had graduated high school.
One day we happened to run into each other
at the local swimming pool.

She had put on a few pounds
and this made her even more attractive than before.
Now at twenty, the way she looked walking around in a bikini,
well, all I can say is, it made your eyes sore.

We talked for awhile,
then I asked her for a date that same day.
She wasn't going steady with anyone,
so she said it would be okay.

I'm going to skip the middle of our relationship
and then continue towards the end,
because what finally took place, always seems to happen
time and time again.

She wanted marriage,
but becauseI felt I was being pressured, I said no.
She said, that's not a problem, I understand,
I'll just pack my things and go.

She did get married and later a divorce
and later called me to ask if we could we get together again.
I said absolutely, I would love to see you,
but nothing serious, just as friends.

- JM

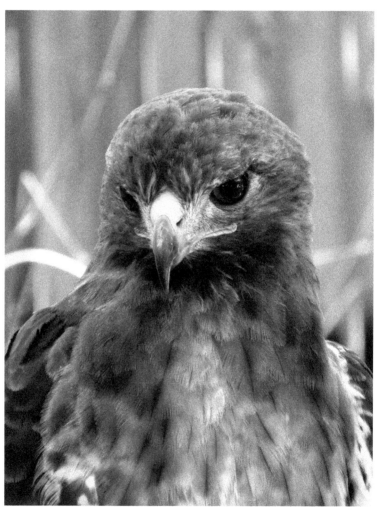

"Red-tailed Hawk, Florida"
Photo by Lisa Manale

Disciplined With Love

If there were any problems when I was very young,
there was no shouting "time out."
My father would just sit me down
and ask what the problem was all about.

He never spanked me
or even raised his voice,
he just took me aside and said you can accept the rules,
but you have to make a choice.

He said, go apologize to your mother
to tell her this will never happen again.
And remember I'm not going to punish you,
I'm not only your father, I'm also your friend.

We all got along well together
in our happy and modest home,
and whenever my parents had something to discuss,
they would always go to another room.

I was so lucky to have a caring and loving family,
although I know I wasn't the only one.
And all this happened from two devoted parents
that loved their only son.

- JM

Tragic Depression

It is still a tragedy,
and so painfully true,
sometimes a person becomes so depressed
that there is nothing anyone can do.

Even when they seek professional help,
this is not always a cure.
they may be having so much pain in their life,
it's more than they can endure.

He was a real good friend of mine
for so many fun filled years.
And you would think someone with his success
could conquer all his fears.

He seemed like a happy go lucky guy
without a care in the world,
and everything seemed perfect for him
until he married this troubled young girl.

She was just a pretty girl in high school
when they first started to date.
All these tragedies later happened
when she had turned thirty eight.

She suffered from bipolar disorder
and this condition is not good,
but as a devoted loving husband,
he did for her what he could.

One day returning from work
he opened the front door and walked inside.
Later he had told his friends
that she had commited suicide.

It was only two months later
when he himself took his own life.
I guess he was so depressed from it all
and just wanted to be with his wife.

- JM

National Suicide Prevention Lifeline 800-273-8255

Anxious Countdown

I want your eyes to be spellbound
the first time you see my face.
I want you to feel so excited,
that you feel your own heart race.

I'll imagine that your smile will be uncontrollable
as you share it so big and wide.
I can't wait until you reach out my hand
and pull me to your side.

I'm looking forward to spending time with you
and to see where this connection may go.
I'm anxious to tell you so many things
and express and laugh and show.

Waiting for the moment you hold me tight
is also what comes to mind.
You and I both realize we're different
and that our hearts are one of a kind.

- LM

I Tried

I ask myself why I want you so
if you don't want me back.
I know I have so much to give
so what it is that I lack?

I have everything a man could want
to keep him happy til the end.
I give everything that's good and more,
I'm a loyal, loving friend.

I've shown everything I can express
to prove myself to you.
Maybe you can't see my worth
or my heart that's full and true.

There was a time when you noticed me
and who I am inside.
I cannot change that you're still healing from pain
but always remember that I tried.

- LM

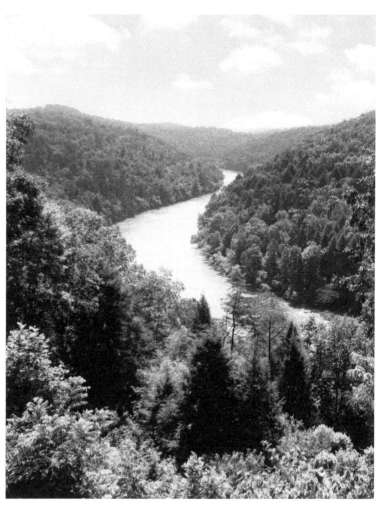

"Cumberland River, Kentucky"
Photo by Lisa Manale

Out of Left Field

I don't know what else I can do for you
as I'm trying my best like I knew I would.
You explained to me all that you are struggling with,
and I told you I understood.

You said that you would reach out to me
to remain my friend and check on me too.
You promised you wouldn't shut me out,
why say it if it wasn't true?

For a moment you appreciated all that I was
and everything I wanted to give.
Then in one day you turned your back on me,
I will never understand why as long as I live.

- LM

Reading Between the Lines

There is an old saying, beauty is only skin deep but ugly
goes all the way to the bone.
I stopped dating this blue eyed blonde for something she
did when we were alone.

We had been dating for weeks and having fun and
everything seem truly seemed fine.
But then I caught her doing something that totally blew
my mind.

The first thing I noticed as I opened the door,
was that she was completely naked and sitting on the floor.

Sitting there naked with a smile on her face was really a
pleasant surprise.
I will tell you that her beauty was a feast for any man's eyes.

She got up and mixed me a drink and asked me to spend
the night.
I said yes, and at that moment, what I saw really gave me a
fright.

I asked her, are all those white lines on the table a joke?
She said no, I make alot of money and for awhile, I've been
doing coke.

I was thinking of what to say to her the very next day.
Should I stop seeing her or forget what happened and stay?

Finally I said, I know you're old enough to do whatever you like,
but I just can't be with someone who does drugs, so I'm going to take a hike.

I'll miss all the things we did together and it will be hard to forget you, that's true.
But who knows, maybe sometime in the future, I'll be seeing you.

- JM

September Rain

You asked me when I first fell for you,
yes I do remember.
It was on a rainy night,
sometime in September.

I met you several months before.
Do you recall, we were wedding guests.
I really first took notice of you
wearing a light blue dress.

Our first date was a dinner,
we sat and talked all night.
This followed with one slow dance,
you were a pure delight.

I'm happy we're still together
after all those years.
Yes we had our ups and downs,
but we conquered all our fears.

- JM

Rely On Me

I'm having a little trouble
trying to figure you out.
You're worth every moment I've been learning
what you're all about.

Please don't ever doubt me
or be worried about what I understand.
The matters that you and I feel and believe
seem to always go hand and hand.

Don't let the emotional side of me
make you run or change your mind.
I'm just a genuine and loving soul
and with me, that's all you'll find.

If you ever feel you're at the end of your rope
and wonder how you'll make it through.
remember I'll give you all that you need
and I'll always be there for you too.

- LM

The Girl For You

Has someone you know ever offered
to fix you up with a girl they think would be perfect for you?
It could be a good friend or a spouse, fixing up two strangers
is a thing some people like to do.

They usually start the conversation by saying,
we have the perfect girl for you to date.
I would always respond by saying,
if she is so perfect, why doesn't she have a mate?

I have often dated girls I have met in nightclubs
or just someone I've known from high school.
And over the years the blind dates that I had,
have only been a few.

There was a couple of girls I could have dated from our office,
but I quickly ruled this out.
It would only give the rest of the girls
something to gossip about.

I don't think you have to hurry
for the right person to find.
If two people really love each other,
this might lead to marriage sometime.

One of the girls I knew from high school,
did become my wife.
Now I don't have to date anymore,
I have a companion hopefully for life.

- JM

Loyal Friend

Yes I know I worry,
it's just a part of who I am.
It's just the way I'm wired,
I always do all that I can.

I respect that you truly trust me,
as you express to me things you rarely share.
I'm happy that you see and realize,
that I only worry because I care.

I'll be here through the ups and downs
and all the days you are on the mend.
You'll never have to doubt my heart
or that I am here always as your friend.

- LM

"Northern California Trail"
Photo by Lisa Manale

The Seemingly Endless Search

I long for the most intimate moments that I've only imagined in my thoughts.

I crave an immeasurable amount of adoration and attention to who I am.

I desire a passion filled bond that I've only read about in books.

I yearn for an unbreakable loyalty with someone that rarely exisits.

I imagine a truthful, honest and sincere partner that understands morals and respect and how to be good to one another.

I wish for my mind, body and soul to feel safe and secure in every way possible.

I want to be touched in a way that every expression shared can be spoken with no words.

I always think about the true meaning of need and that I need my emptiness forever filled.

I covet a solid and genuine friendship that I never have to doubt.

I hunger to give endlessly and wholeheartedly like no other.

I dream of a true love that I've never seen before, that will never die and will change my life for the rest of my days.

- LM

First True Love

Several nights a week I would leave my parents house and
walk to a phone booth six blocks away.
I needed to talk to my girlfriend and didn't want my parents
to listen in on what I would say.

I know this may sound silly but if you're sixteen and like a
girl from school,
this is just one of the weird things that young people think
is cool.

It was worth walking the distance, just to talk puppy love
over the phone.
My parents would never let me talk for hours if I were home.

In a phone booth there was no way I could stand for an
hour or more,
so I would just relax and sit on the floor.

Once I asked her if I could come over and visit one day.
She said she would have to ask her parents then let me
know what they would say.

It would sometimes take five minutes for us to hang up the
phone.
Then after another night of talking, I would stand and walk
back home.

We finally got married and raised a nice family.
I guess all those hours of talking finally paid off for me.

- JM

Fond Memories of You

They played our song on the radio the other day.
It was a tribute to Jackie Wilson, our song was first to play.

I'm not telling you this just to bring up the past,
about a romance that we both thought was going to last.

Those bright sunny days that we used to share,
no one could have imagined that love was going nowhere.

It was fun while it lasted, yes this is true.
It wasn't all a waste, the years of loving you.

I'm not going to deny our love, for I would be a liar.
But you should know your love kept lifting me higher.

- JM

"San Salvador Island, Bahamas"
Photo by Lisa Manale

Somewhere, Some way, Someday

I find myself trying desperately to understand why this happens to me.

I do my best to protect my heart but the moments I least expect it, a unique and beautiful soul finds their way in somehow...and then I suddenly feel safe into giving all of myself with no reservations.

I know the risk but I do it anyway.

I believe I take these chances and sacrifice the possibility of getting my heart broken over and over again because I long to find what will fill my emptiness.

My heart aches terribly at these moments because I wonder if another soul wants the same and finds the worth in meeting me halfway to learn, grow and enjoy the journey together.

A remarkable man who is not perfect, but he is for me; who has experienced tremendous pain as well but always finds its purpose, who may run and hide at moments but will be there for my needs, who may have inner battles but will allow me as their friend, to help, who may struggle to understand me at times but will never let me down.

If such a person knew that I give and love like no other in a way they believe does not exist, they'd have to be ready to experience an overlfow of love in their heart.

Pain has made me show love and passion like never before and I know the person who gets that will find me, notice me and never let me go.

Somewhere, some way, someday...

- LM

Unconditional Love

Of all the things that have happened to me,
this I will confess.
I would say having a family
would be at the top of the list.

Just sharing things together
brings so much love into a home.
And whenever there's a problem,
you know you won't face it all alone.

I am thankful to be blessed
with so much joy and happiness,
but sadly I know of families
that have had little or no success.

Because parents are busy
they don't know if everything is okay.
They just hope all will be fine
by the end of the day.

At first their children just skip school
but then later on commit a minor crime.
A few are sent to juvenile homes
where they will serve some time.

These minor crimes bring shame to families
and sometimes can create financial stress.
Still with all these problems, families will try
to work through their children's mess.

- JM

Fighting to Let Go

I remember the day you showed up at my door
to tell me our relationship had to come to an end.
We were both so heartbroken in so many ways
and what made it worse is we couldn't be friends.

We both laid on the floor uncontrollable with tears,
as neither one of us wanted to part.
It was a horrible day for the both of us,
we were both losing a piece of our heart.

You had called me on the phone that very night
to painfully tell me that you had to leave.
You had to go and make certain choices for yourself
while I was left alone to heal and grieve.

Our friendship had blossomed when we met at work,
we never ran out of things to say.
From Happy Hours downtown, fun filled lunches all
around,
we made time to see each other every day.

You made me feel love deep in my heart
in a way that no one else had before.
From enjoying different music and smoking a cigar,
whatever we did, you never stopped wanting to show me
more.

I smile when I think about when you took me to the orchestra,
as it was another thing I had never done.
It was just another unforgettable memory with you,
we never stopped having fun.

I have never been so close, so intimately,
to have secrets I'll take to my grave.
Everything we had and everything we did,
will be a memory I will always cherish and save.

It took years for me to heal with my broken heart
and somehow get myself through.
Four years later I was shocked when you showed up at my
door,
my heart sunk, I didn't know what to do.

We caught up on my couch that very day,
expressing words that had never been said.
I was anxious and nervous of why you were there, but with
tears in your eyes,
you told me you were sorry and kissed me instead.

You told me the days had been difficult for you
and the struggles of where your heart has been.
You asked if I wanted to see you and my mind said yes,
but I could not put my heart through it all again.

It's been twenty years since that day with you
and I think of how you touched me so.
I wish I could just hear your voice again
and tell you that I never wanted to let you go.

- LM

Love Is A Gamble

Don't you slip away from me
or slowly fade out of sight.
Sometimes you just know when something feels good
and it feels so right.

I know we're both uncertain
of what will happen or where this will go.
Whatever it is we do have,
let's stay connected and make it grow.

I understand we're both afraid
and trying to protect our heart.
We just want our minds to be in a good place
and our lives to have a brand new start.

So it's important that you don't give up on this
because you already mean alot to me.
I hope this friendship grows into something more,
we'll just have to wait and see.

- LM

"Cheaha State Park, Alabama"
Photo by Lisa Manale

Jenny

Her name was Jenny and we both attended the same school.
I know this sounds ridiculous, but just looking at her made
me drool.

She was one of the girls in school alot of guys would want
to know, and not only was she attractive, but to me, she
emitted a special glow.

Besides her apparent beauty, she had long red flowing hair
and when we had lunch in school, some guys always
stopped to stare.

When she would walk, her footsteps were as light as a
feather.
And to see her walking barefoot on the beach is a sight that
will stay with me forever.

There are just some women that are more feminine than
others and men will always take notice when they are
talking about women to each other.

Jenny's skin was smooth and supple, that's just the honest
truth.
It's just one of the advantages of something we all know as
youth.

Even now when I hear the name Jenny, my thoughts
immediately revert to the past for all the time we spent
together and thinking our love would last.

There are millions of women like Jenny that possess both
brains and good looks.
But what Jenny really had was truly one for the books.

- JM

Centaur

I believe the perfect fantasy animal would be a centaur.
Of all the different creatures, this would be the best by far.

We all know this animal only exisits as a myth of course,
but just imagine the benefits of being half man and half
horse.

With two stomachs, you could eat the foods that both
humans and horses do.
You could even combine them, the choices would be up to
you.

There will always be grass and oats to eat
or you could have a hamburger, fries and something sweet.

You won't need a bicycle or automobile for transportation,
you can walk, trot and even gallop to reach your
destination.

Too bad the centaur only exists in Greek mythology,
for a stud is something I've always wanted to be.

- JM

Under Pressure

After seeing each other for a year,
she asked me the one question I've always dreaded.
She turned to me and said,
I'd like to know where our relationship is headed.

And although we both shared many
of the same interests with each other,
I knew the answer I gave
would change our lives forever.

I was tongue tied for a moment
and really didn't know what to say.
She smiled and looked at me, then said straight forward,
I would like an answer sometime today.

For all the times we have spent together,
I knew she would make a great wife.
But marriage and a family
was one of the biggest decisions in anyone's life.

Have you ever felt that someone
has put a gun to your head,
and if you gave the wrong answer,
you were as good as dead?

I guess alot of women
want to settle down someday,
and guys like me are just one
of several relationships along the way.

I said I really do love you
but this is something that's never entered my mind.
I figured we were both happy in our relationship
and things were going just fine.

It's a life long commitment
and I don't know what to say.
She said, call me after you've made your decision,
you have till the end of day.

- JM

"Osprey, Florida"
Photo by David Minter

Settling Will Cost You

Searching for that great guy
with a halo he cannot hide.
But you always find yourself with the bad boy
that innately has the devil inside.

You're always looking for that sweet man
that is wonderful, kind and nice
but you always end up with a mean hearted jerk
where you settled when you should've thought twice.

You hope if maybe you meet a man of God
he knows how to treat you like gold.
But you're always drawn to the rebel who has so much to
learn;
the troublemaker who never does what he's told.

You wonder who is out there who is simple and calm
and who always makes everything all right,
but you always choose the loudmouth who is complex and
cold
and that always seems to argue and fight.

You see your pattern in choosing men
only after the years have gone by.
You try to justify why you're not attracted to the good ones
but until you change, you'll keep living a lie.

You question what is wrong with you
and if the man of your dreams truly exists.
Stop giving in to unworthy souls
so the time for the right one will not be missed.

- LM

Life's Patterns

This journey that I'm on, sometimes I don't understand it. Sometimes I think I found the answers but then something or someone reminds me that it's not that easy.

You want to believe you can overcome every hurdle and defeat every challenge that comes your way but resistance is a certainty.

You take chances because that's what you were taught and because you won't know the outcome until you do.

You try not to repeat your mistakes and you try to convince yourself that you've learned from them but, you do repeat them.

You start to realize your life decisions become a series of patterns.
You ignore red flags and let the good ones go.
You put off visiting someone and then find that they pass away.
You bypass how to save for a rainy day and then you're stuck starting over again.

As the years have gone by, you believe that you know so much more but we're always learning. Changes and challenges are imminent.

You are in a never ending game of life.
There are no rules and you rely on your resilient
determination to stay alive.

- LM

Day at the Fair

I remember when I went from the eighth to ninth grade,
I felt I was all grown up, figured I had it made.

The state fair had already been to alot of other towns,
and when it came here, friends would make plans to meet
again at the fairgrounds.

I had a crush on this cute girl in my class and she told me
she was going to the fair.
So I got up the nerve and asked if I could meet her there.

When she answered yes, I was really surprised,
because she had been asked by a few other guys.

Our little group met, bought our tickets then hurried
through the gate.
I was excited when I saw her walking towards me, for this
was our first date.

Our group stayed together, we had loads of fun.
But the day was really hot, no clouds, only the sun.

We enjoyed both the food and the rides, and did alot of
walking around.
But everybody had to be back home when the sun went down.

- JM

Slipping Away

Chorus
Please don't slip away
I feel it more and more each day
Anything to make you stay
please don't go away.

Verse 1
Do you recall our talks, the passion and my touch?
You used to want it often and now not so much.
You used to smile with our kisses and the way I looked at
you with my eyes.
Now I sit and wonder with all the worries and the whys.

Chorus

Verse 2
You used to desire our intimacy driving miles just to feel
the good.
Now I beg for those moments once more instead of
wondering why now
it is so misunderstood.

Chorus

- LM

Get Along

Verse 1
All these struggles that we've been through,
made us stronger every day.
Broken hearts and troubled times,
Losing friends along the way.

(Chorus) 1x
Believe in your heart it will get better,
The love inside will get us through.
There's no time to waste in this short life,
Give your best in all you do.

Verse 2
The days we struggle with tragedies,
Stop ourselves from falling down.
Always hopeful what's ahead of us,
How it all will turn around.

(Chorus) 1x

Verse 3
Blissful memories gone forever,
Thinking back on days gone by,
There's still time to come together,
We'll get through, We'll get through, We'll get through...

If we can get along,
Get along, Get along, Get along
We can get along
(repeat)

- LM and Co-Written by Tony Arnone

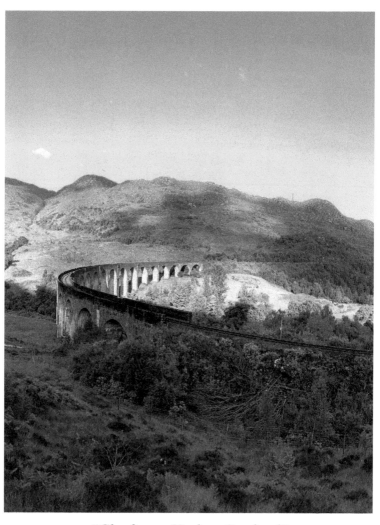

"Glenfinnan Viaduct, Scotland"
Photo by Jeff Hartzog

Dismissed

Forgive me if I'm harsh and seemingly,
come off as so obtuse.
But time after time, nothing changes,
you always come up with a new excuse.

No matter what seems to be going on with you,
I hope you'll see the basis for my rant.
You come up with any story when it's convenient for you
and find any reason to say that you can't.

It's amazing the effort you give of yourself
when trying to get out of a plan.
Why be misleading of why you can never make time,
just be honest and be a real man.

- LM

Double Dilemma

I know so much about her
yet she knows nothing of me.
How long can we keep a secret
when it involves just us three?

I know her name and number
and the reasons why the moments we have missed.
She knows nothing of what you and I have shared as one
or that I even exist.

Over the months we have done so much,
laughed and had so much fun.
You say you somehow love her as you're laying here with me,
clearly she is not the one.

You already know the secrets we share
and how I feel deep down inside.
But you continue to not let her know about me
and from her, it is me you will hide.

It has been diffcult for me to not express myself
as I hold back my thoughts and have so much to say.
You know I have loved you from the very start,
I don't know how long I can keep it this way.

I wonder what she would do if she found out about me,
if she'd walk away or just break down and cry.
Something that you and I have already been through,
this is what happens when you're living a lie.

You want us both for all the wrong reasons for yourself which will only end up falling apart.
We must both make decisons that will change our lives, you have already taken all of my heart.

- LM

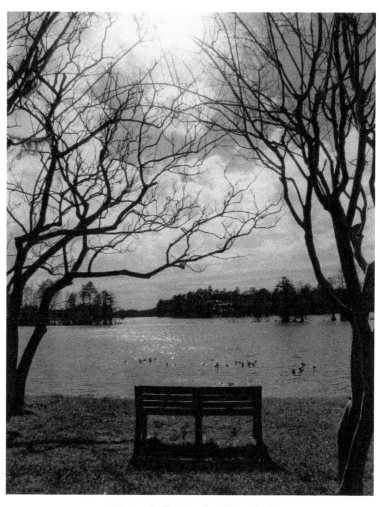

"Riverhills Park, Florida"
Photo by Lisa Manale

Simple Solitude

Life is so much simpler
spending time by myself.
Just me and my cat and my fish,
and the books upon the shelf.

Life seems so much easier
living it all alone.
No loud talking, fighting or arguments
or long discussions on the phone.

Life feels so much better
when I have no tears to cry.
No anxiety, worries or heartache
or having to say goodbye.

My life is much more peaceful
as I protect my heart and keep people away.
The days may sometimes get lonely,
but my peace of mind is here to stay.

- LM

Agree With A Smile

A woman will do anything for you or to you,
I once heard an old man say.
And women can make alot of trouble for a man too
if they don't get their way.

I know there are women that have a mean streak
just like some men do.
But I don't think most women
would want to physically hurt you.

Stories like Lizzie Borden's
may or may not be true,
but just make sure no one
has an axe to grind with you.

I know some women can cause trouble
if their wishes are denied.
So just to be safe,
I suggest you stay on their good side.

- JM

No Apologies, Regrets or Tears

I have always enjoyed the beauty of flowers,
for they really are a feast for the eye.
But sadly their beauty will not last,
for they bloom, weather and die.

But unlike our one time love affair,
there is no suffering and no pain.
I myself will have to think twice
before I fall in love again.

But I do remember the first time we met,
was a year ago or two.
I talked briefly with you at a wedding,
I was completely taken with you.

Thought about you ever since,
that may sound silly, but it's true.
From the moment that we met,
I had a thing for you.

I was excited when we finally found each other
and the love we shared for awhile.
Then we soon found that nothing lasts forever
but our romance still ended with a smile.

Then, finally love went away
after all those wonderful years.
We now have gone our separate ways,
with no apologies, regrets or tears.

- JM

Will I Ever See You Again?

Do you ever not want to see my face again?
You seem to be okay with that.
You've become so closed over the weeks,
I don't even know where your head is at.

You only reply to all the messages I send,
you never reach out first on your own.
You are so guarded with your words and avoiding my thoughts,
rarely calling me anymore on the phone.

What happened to the man that was crazy about me,
less than a year ago?
The care you expressed, the interest you showed,
we always had so much fun.....where did you go?

You say you respect and look up to me
and that our friendship will always remain.
I trusted when you said you would not shut me out,
but what you're doing is not the same.

I make all the effort to keep us close and as agreed,
to be always be in my life some way.
You act like I don't even matter anymore,
would that be the case if I left this world today?

So I'll ask you once more with tears in my eyes,
Will I ever see your face again?
It's all about saving the special connection we have,
or regret losing me forever as a friend.

It just doesn't make any sense to me,
our friendship should be growing stronger, not further apart.
I've never asked very much of you,
just not to fade away or throw away my heart.

- LM

My Dad and co-author, Joseph Manale

Dad

As I sit here feeling so lost
and just staring into space.
I'm struggling with the devastation
of the last time I saw your face.

We had such a wonderful long weekend
as we undoubtedly always do.
We were having our final Christmas together,
something both of us never knew.

I'll try and remember only the good times we had
and the many memories over the years.
Time may bring some comfort that you are at peace
but it will never take away my tears.

You were selfless, giving and loyal to many
and as a father, you were simply the best.
I know you wished you could have done so much more
and believe me, you did with all the love you expressed.

I already miss you so much, Dad
and pray to get through the days without you here.
My heart breaks that I cannot hug or talk to you
although I know you'll always somehow be near.

So I'll do my best to live without you for awhile
and remind myself that you are okay.
The only light that keeps me going on
is that I'll see you again someday.

I love you eternally, Dad...
Lisa